1981

Making
Woodcuts

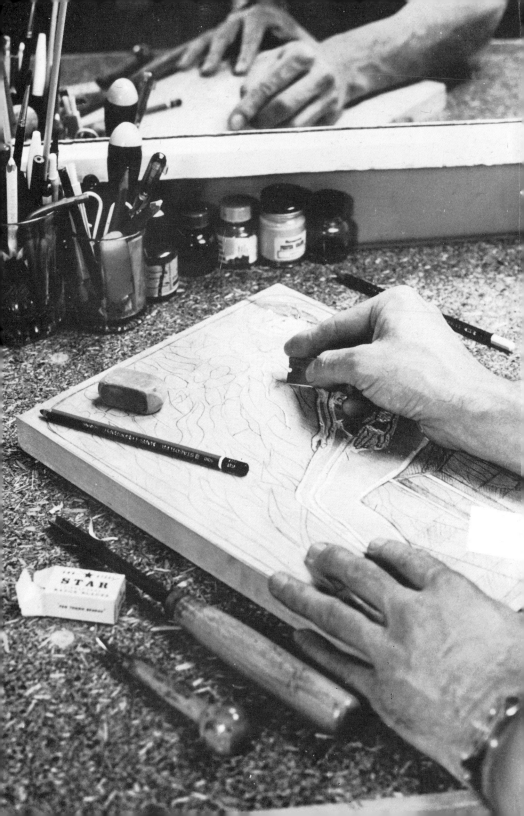

Making Woodcuts

Warwick Hutton

A Scopas Handbook

Academy Editions - London
St. Martin's Press - New York

Scopas Handbook

Series editor:
Christine Bernard

First published in Great Britain
in 1974 by Academy Editions
7 Holland Street London W8

Copyrights © 1973 Academy Editions;
all rights reserved.

First published in the U.S.A.
in 1974 by St. Martin's Press Inc.,
175 Fifth Avenue, New York N.Y. 10010

Printed and bound in Great Britain
by The Devonshire Press, Torquay

Library of Congress catalog
card number 73–79594

SBN hardback 85670 122 X
SBN paperback 85670 127 0

Frontispiece
Cutting the block with a razor blade.

List of Contents

Introduction

I have written a description of a practical, moderately difficult craft which is used to transmit a fine art image. Throughout the book there have been two basic difficulties. The first is that it has seemed wrong to me to declare rules when I know that the principles that appear to govern the craft have all been successfully broken at some time or another; and to make it even more confusing, the best artists have often been the best rule-breakers. The second problem is that today, the practice in most print mediums is to extend the various techniques to their furthest limits; modern materials, adhesives, electric tools, all are experimented with freely. Sometimes even seemingly opposing mediums are mixed together. The result for anyone approaching woodcut for the first time can be a chaotic and intimidating scene.

To both these problems I have taken the obvious but, I think, honest way out, by describing the *basic* way the craft has seemed to work for me, showing one or two departures from this path while expecting readers to try many more.

Some of these rules I have learned the hard way over the years; how many painful hours I would have saved for a few undiscovered facts I have since learned. For many years I cut woodblocks on the floor with a single gouge chisel which I did not know how to sharpen, while my prints were produced with a tablespoon. Although my methods are now a bit more refined, the truth that has emerged is that if the idea is strong enough the method matters little.

Chapter I

Historical survey

Like so many inventions, the idea and principle of the woodcut comes from the Orient. The art of printing is known to have begun many centuries ago in China, and, not unexpectedly, man's most consistently used material—wood—has been the obvious choice for printing blocks. Although it is likely that China produced the very first pictures printed from wood, Japan can claim woodcuts from the eighth century, and it is in this country that prints from woodblocks became one of the most deeply-rooted forms of art. It developed with such feeling and intensity that when Japanese prints suddenly arrived in Europe in the nineteenth century—often only as packing paper for tea or porcelain shipments—the stir they created in Paris art circles proved to be one of the most far-reaching influences of modern art.

The earliest Japanese woodcuts were small and simple religious pictures distributed by Buddhist priests. Designs were supplied by an artist and pasted onto a plank; a craftsman then removed the surface of the wood between the black lines of the design, leaving these lines to stand in relief. This is still the basic method of woodcut. Ink was then applied to the surfaces, paper placed over the inked block, and after careful rubbing on the paper back, the finished print was peeled off, an exact reproduction, in reverse, of the artist's original design.

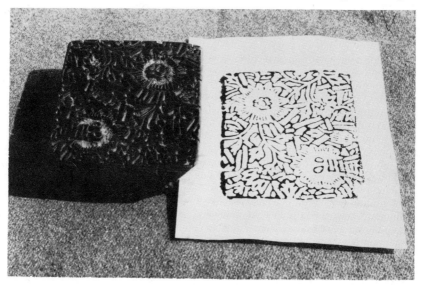

1. Early Persian woodblock and print for fabric printing

Woodblocks first arrived in Europe when Eastern trade and over-land caravans began to penetrate the West. At first they were only used for fabric printing, as paper was not commonly available at that time. The Chinese processs of making paper from flax and old linen reached Turkestan in 780. Spreading rather slowly through Islamic culture it reached Spain and then Italy. By the first half of the four-teenth century, Germany, too had mastered the craft of papermaking. Thus paper-mills began working, and woodcuts printed on paper made their first appearance in Europe.

2. Religious mementos, Spanish, 16th century

The first images were playing cards and mementos, or, as in Japan, simple religious pictures. The first quarter of the fifteenth century produced woodcuts with strong thick lines and blank spaces between; understandably they were close in quality to the stained glass windows of the period, and when they were coloured by hand they looked very similar.

Very gradually and slowly a few half-tones were developed, simple hatching appeared, and colouring became less necessary. Instead of a skeleton or pattern of black lines containing areas to be coloured, three-dimensional figures and scenes were attempted. These early woodcuts were the first cheap, easy-to-produce pictures, probably the first pictures ordinary people could see and handle themselves. They were used eagerly for many different purposes, on walls, on furniture and box lids, while prints of saints were used to make small domestic altar pieces.

Today we use graphic work in a vast range of media: for posters, books, papers, packaging, etc. We see so much of it we scarcely notice its numerous uses. In the fifteenth century, except for the more laborious metal engraving method, the woodcut was the only avail-

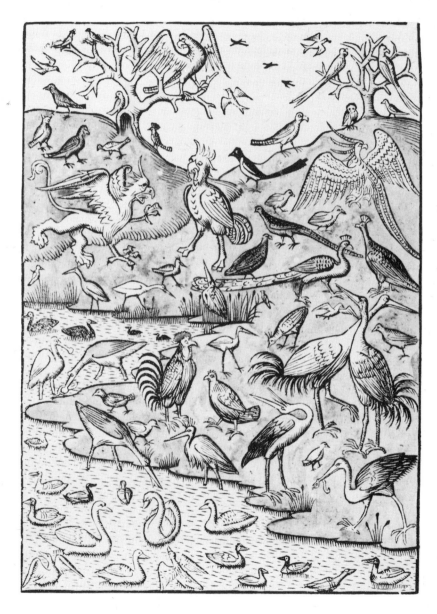

3. Bartholomaeus, *The Birds*, Holland, 1485

able way to mass produce pictures. It is easy to imagine with what enthusiasm it was used for every occasion.

Pictures were sometimes titled or described with writing cut on the same block and this led to so-called 'block books' which first appeared about 1455 and were still being produced at the end of that century. However, as the printing presses took over, a highly important change took place when hand impressions ceased to be taken. Now much finer prints could be produced, showing detail that impatient hand rubbing might have blurred, and as these presses were usually used for printing books, the two forms of print came together.

The first known book set with movable type and illustrated with woodcuts was Boner's *Edelstein* of 1461. By 1471 woodcut production for printed books was an organised business. Publishers employed designers, copyists and cutters who drew, adapted and engraved book illustrations. On occasions two editions were produced, a more expensive version with colour illustrations, and a cheaper one in black and white. However, the style of the prints remained simple and the shading somewhat unsubtle.

An important change was effected by Michael Wolgemut, who reversed the existing situation; an artist and engraver himself, he found financial support and together with his step-son, Wilhelm Pleydenwerff, employed a printer who by good chance was Anton Koberger, Dürers' godfather. The result was two famous books, the *Schatzbehalten* in 1491 and Hartmann Schedel's *Nuremberg Chronicle* in 1493.

The contrast is complete, the woodcuts dominate the text, new dimensions in tone and scale were achieved, depth and bold foreshortening, cross-hatching and greater form solidity were used. The *Chronicle* contained no less than 645 illustrations, some as large as ten by fifteen inches. With this greater tonal range colour was unnecessary, and although at times the quality was variable; compared to some of his French and Italian contemporaries the work could be said to be tasteless in a violent and lively way. It was on this active and fertile business that the genius of Albrecht Dürer was cast.

In 1489 the young Dürer entered Wolgemut's illustration workshop. There are no records of the woodcuts he produced in these early years but both the *Schatzbehalten* and the *Nuremberg Chronicle* were in production at the time and the many hundreds of illustrations in the hands of workers at the shop. It is almost certain that Dürer's hands were some of the many that cut these blocks. Indeed some art historians say they can identify the ones he did. At any rate we know

that here he had a thorough and practical grounding in woodcut production and that as a result later woodcuts were nearly always cut with his own hands.

Dürer was one of the first great artists to immerse himself so completely in a print technique; there are many later examples,

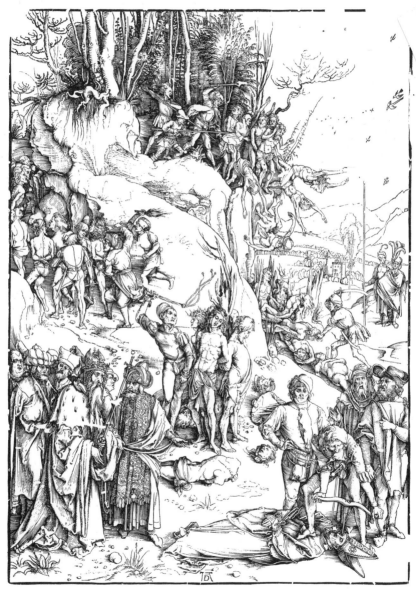

4. Dürer, *The Martyrdom of the Ten Thousand*, 1496

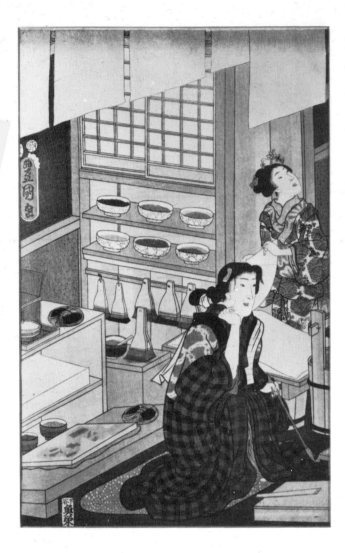
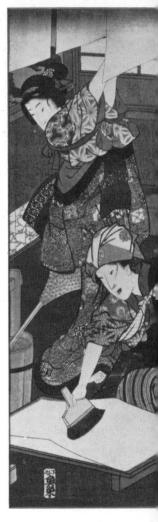

Rembrandt concerned himself with etching, Bonnard and Vuillard with lithography. Toward the end of his life Dürer even preferred woodcuts to painting; besides being more profitable, woodcuts reached a larger public and allowed a much freer range of subject matter. In late mediaeval times artistic techniques, particularly in painting, were handed down gently from age to age; a new medium like woodcut had fewer traditional encumbrances, and was thus a much freer form of expression. Although the engraving of a wood-block might seem slow and painstaking, painting at that time was

6

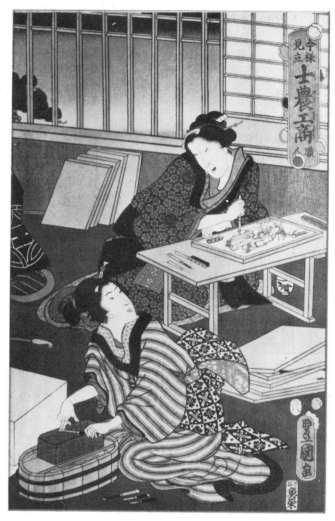

5. Kunisada (1786–1864), Japanese women making colour prints

usually much more so. Subject matter suitable for a well-to-do patron or church altarpiece was somewhat limited, and always there would be many previous versions for reference and comparison. It is no wonder Dürer became increasingly absorbed with his woodcuts, much more daring ideas could be drawn out, day-to-day subjects, even political matters could be dealt with, all unheard of in painting. It is no coincidence that a completely similar subject separation occurred with Japanese woodcuts centuries later. In 1528 Dürer died leaving the art of woodcut thoroughly planted in the culture of Europe.

7

Meanwhile in Japan techniques had advanced steadily; by the fifteenth century, block cutters had reached a very high standard of skill, although the move towards half-tones, which created the rounded forms and three dimensions that occurred in Europe, was never made, and the woodcut remained a design which had to be coloured in. The demarcation of artist, engraver, and printer continued and was to become the essential rule of Japanese printmaking, only just broken by present-day artists.

Following a period of recession the Japanese, in the middle of the seventeenth century, started to produce illustrated books; as their popularity grew, more and more woodcuts were required. *Ukiyo-e* means 'reflections of the passing world', or more colloquially translated, 'scenes from everyday life', and the phrase signals the beginning of the great period of Japanese prints. At first it referred to paintings of day-to-day peasant life, but the growing art of woodcut prints slowly developed through black and white, then hand colouring, and finally, with the use of additional colour blocks, the full complexity was reached in the eighteenth century in the prints of Suzuki Harunobu, one of the great names of Japanese woodcuts. Others soon to join him were Utamaro, Hokusai, Hiroshige.

Not surprisingly the techniques used were completely different from Europe. In colour printing, for instance, the colour could be put on the block as a dry powder and then mixed with a thin rice size, which as a medium produced a brilliant quality of colour. More usually however, colour was applied with brushes, it could be toned slightly or even spattered to make the effect richer. Occasionally one block was used for two colours, but usually only when the colour areas were well separated. Like those of some present-day printmakers, these woodcuts tended to be much more individual; each print involved so much work that it was unlikely to resemble its successor exactly.

Printing was done quite simply by burnishing the dampened paper with a tool called a baren, a small round pad of bamboo leaf packed with paper and cloth. Sometimes an embossed effect was obtained by rubbing hard on damp paper and a clean block. The printers always used very simple registration methods, but since their work was fairly constant—the advantage of the artist/cutter/printer demarcation—their skill and accuracy was of a very high order.

In Europe a break away from woodcut craft was made by Thomas Bewick of Newcastle in the late eighteenth century. Instead of cutting into the side grain of the wood he cut into the end grain. It had been

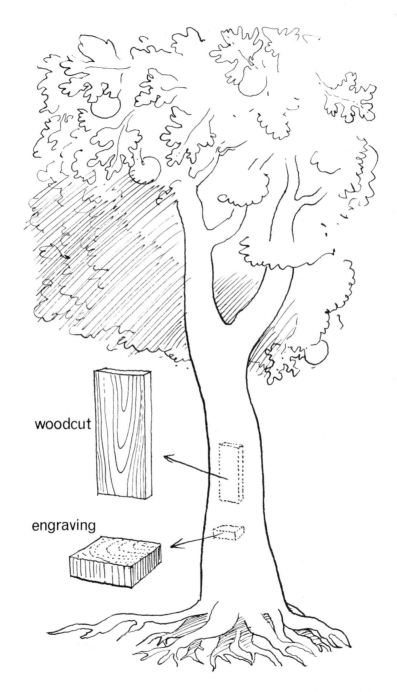

woodcut

engraving

6. Showing the origin of woodcut and wood engraving blocks

done before but Bewick was the first to show its true potential and natural use. This method is called wood *engraving*. The woodcut/engraving confusion exists for many people. The blocks had to be smaller, usually made of boxwood, but there were no difficulties with splitting and splintering the grain. A hard even surface almost like a metal plate was the result, but the quality was altogether new. This method was beautifully demonstrated in Bewick's *History of British Birds* which first appeared in 1794.

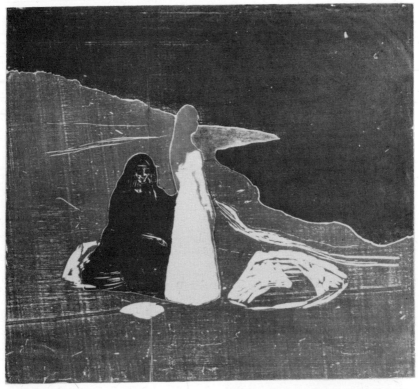

7. Munch, *Two Women on the Shore*, printed from a block cut in three pieces (note how the part of the block which prints the promontory has broken off and had to be hand coloured), 1898

Size is always a problem with wood engraving blocks, sometimes even a small block has to be made of many pieces joined together, and for this reason it is much more suitable for book illustration. In fact it seems that this small difference in the direction of the grain divides illustrators and painters, even today, and continues to confuse dealers and collectors, although its significance is clear to anyone who has tried both; wood engraving is precision and detail, woodcut is size and expression.

10

Books, magazines, papers, now used the greater detail that wood engraving offered. By the middle of the nineteenth century, with the world of commercial graphics and illustration taken over by the wood engraver, woodcut became a rarer craft. Its qualities of power and

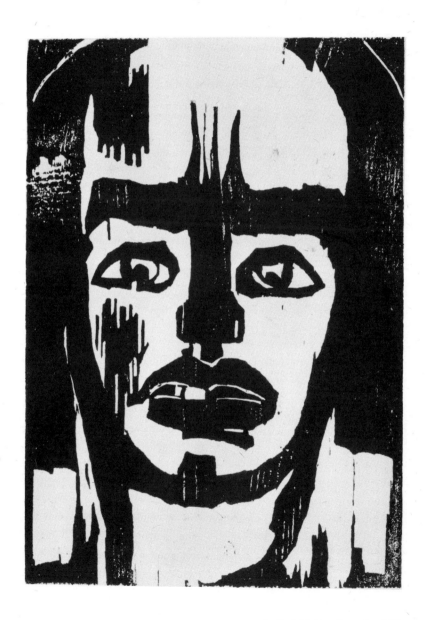

8. Emil Nolde, *Kaempfer*, 1917

expression were used only by a few painters. Germany again provided some of the best woodcut prints. But first the Norwegian, Edvard Munch, was to show new directions by his use of softwood blocks, sometimes scrubbed to exaggerate the grain, sometimes cut out and fitted together for printing like jigsaw puzzles. Munch was one of the first 'expressionists' and woodcuts seemed the perfect medium; even his paintings and lithographs have an intense line and rhythm that is close to softwood grain patterns.

At the beginning of the twentieth century a group of painters calling themselves the *Brücke* was founded in Germany, unmistakably showing the strong influence of Munch; Nolde, Kirchner, Heckel, Pechstein, all produced woodcuts of simplicity and force.

Meanwhile *Ukiyo-e* prints, although so well appreciated in the West, had a difficult time in Japan because of their day-to-day subject matter and multi-production methods. They were never regarded as fine art, in spite of their acclaim abroad, and from the middle of the nineteenth century a decline set in. The colours of the early prints, made from natural vegetable sources were subtle and beautiful, but soon small leaks in the cultural fortress that was Japan—mainly through Dutch traders—enabled new Western dyes to reach the woodcut printers. Particularly noticeable is a rather fierce blue that appears in the prints of Hokusai and some of his contemporaries. After a while disinterest set in, and soon the different craftsmen needed for the whole process disappeared. There were a few, Goyo Hashiguchi among others, who tried to revive the old Japanese print method, but Western influences, misunderstood, filtered in. These Western ideas soon flourished and art in Japan, used to isolation for so long, was understandably confused.

The woodcuts of Munch were very impressive to those in the East, but it is clear that the prints Japan threw away in odd packing cases to the West were far more stimulating to the art of Europe than any returning influence. Only in recent times have Japanese printmakers sorted out the advantages of their own traditional woodcut methods and European artistic styles and values. The results are very successful but they are often surprisingly close to the original Japanese wood-cuts. As if to demonstrate the curious circular way in which art moves, many contemporary artists in Japan are interested in the early, more direct woodcuts, and even hand colour their prints.

The stir that had been created when Japanese prints first arrived in Paris had had its effect on most mediums except the woodcut, the techniques used being far too sophisticated for the West to follow.

It was their essential quality of broad colour areas, extremely sensitive line and uncompromising two dimensions which so fascinated artists.

Although Gauguin was not interested in this sophistication, he saw in woodcut another aspect of his return to primitive nature. He knew only too well the high degree of skill demonstrated by contemporary illustrators and loathed it. His reaction was as strong in his woodcuts as it was in other areas of his life. Ignoring all textbooks he hacked into his blocks with unconventional tools, and the results were startling and quite individual. Often coarse and rough looking in detail,

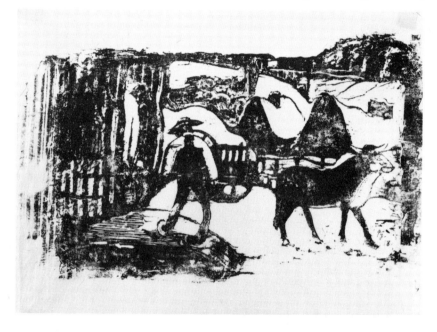

9. Gauguin, *Le Char à Boeufs: Souvenir de Bretagne*, 1900–1901

with blocks covered with marks where the tool slipped, half-tones of many different qualities were obtained by bruising and scoring the wood. At all times the force of the original idea seemed to bend all technical rules to Gauguin's own ends. On occasions Gauguin coloured the prints either with water colour or additional blocks. In 1921 his son Pola made an edition from the original blocks which are among the best surviving Gauguin woodcut prints.

Vlaminck, Dufy, and Picasso in their work in various mediums have used woodcut with the success that is typical of these masters. Other modern painters who have tried different mediums usually

come to the oldest of all; woodcut responds to the forceful directness of Nolde as well as it does to the subtle tones of Harunobu. Contemporary printmakers too have found that blocks can be made of plywood and worked with an electric drill or carved as carefully as the woodcutter of the fifteenth century. Most artists use a press in the Western hemisphere but Japanese artists still work with a baren, although they cut and print their own block.

Of all graphic mediums woodcut is the oldest. After years of commercial entanglement it is now free and many artists have seized upon its original advantages. No other medium is likely to supplant its force and power, and as print complexity and popularity increase (both have increased enormously in the last decade), many artists are today turning to the simple strength and basic principles of woodcut.

Chapter II

Materials and tools

Wood

Almost any wood can be used for a woodblock provided its surface is level and relatively smooth. However, for convenience the materials can be divided into three distinct groups; hardwood, softwood, and wood compositions (plywood, chipboard, etc.).

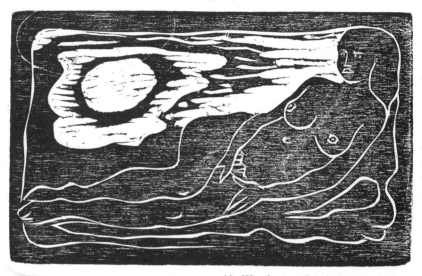

10. Woodcut on flooring-grade plywood

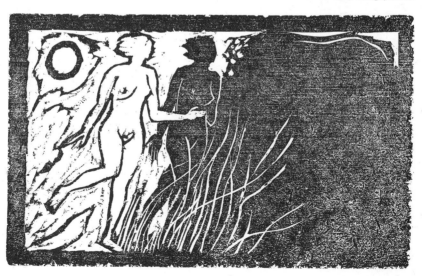

11. Woodcut on chipboard

Most early craftsmen chose hardwood for their blocks, Dürer usually used walnut, a strong wood that could take fine detail without splintering; softwood appeared mainly as a cheaper, less serviceable substitute. It was not until the nineteenth century that Munch showed the special qualities of pine wood, and from then on softwood, mainly ordinary deal planks, has been used more commonly.

In modern times all wood suppliers carry large stocks of plywood, blockboard and chipboard, as many artists are now experimenting with these new materials that are man-made mixtures of wood and wood fibres. Nearly all these materials, depending on the particular quality the artist is searching for, provided the original rule of level and smooth surface stands, are quite suitable for the woodblock artist. It can be seen from the illustrations the sort of print quality each material produces.

Hardwoods most commonly used are cherry, pear, and sycamore, but if you can obtain supplies of other wood in block form, flat and well-surfaced, they will nearly always make good woodcut blocks. The subtle differences in quality of each wood are too many and various to describe in this short book, though many people find the constant close-grained effect of woods like beech and mahogany unhelpful while others use these surfaces quite happily.

The beginner is well advised to start with sycamore or cherry and never dismiss any other hardwood that might come his way.

Remember it is always a bit cheaper to buy wood straight from a wood yard. Art dealers, in any case, will have very limited stocks of woodcut blocks, but what they do supply will have a very perfect surface; patience and a sharp eye, however, can usually obtain the next best thing much more quickly and cheaply.

Some sources might be quite unexpected; most households have in attics and outhouses, discarded furniture, disused shelves, picture backing, and old boxes, to all of which the original rule applies. Even a mild attack of woodworm can be ignored, since the minute holes are unlikely to be much trouble in the design—although it is always wise to treat and kill the infection. As long as the wood is smooth and flat it may be used for a woodcut block.

The thickness of the block is not of critical importance. As a rough guide a large block of about 250 mm x 360 mm seems to be supplied at a 23 mm 9/10th's thickness (type height) while a smaller block of about 150 mm x 200 mm may be only half this thickness.

It should be borne in mind that a block which is very thick is heavy and awkward, and is more difficult to keep accurately flat, especially if it later warps. A block which is too thin is equally awkward to use and cut, and there is always a danger that it will split or break up completely as it is worked; cutting the block with large gouges and a mallet can be a fairly energetic procedure. However, thin blocks do have quite a few advantages: in the printing process they can easily be built up to a convenient working height, and their inherent weakness is an advantage, since any slight warping will be pressed flat momentarily by the press, while a warped block which is on the thick side will crack open. The press will in any case, be unable to accommodate woodblocks over a certain thickness without radical adjustment, so before embarking on such a block it is wise to check the press you intend to use.

If no press is available and printing is to be accomplished by the burnishing method, many of these 'problems' need not be considered, since both the height of the block and accurate flatness are much less important.

Softwood for woodcut blocks is not usually supplied by art dealers but is readily available in the form of ordinary deal planks from any building supplier or wood yard. The word 'deal' is used in the building trade to cover all softwood planks from evergreen pine and coniferous varieties. Often the supplier will have no idea what tree the wood originally came from, but the quality and his price usually depend on the number of knots per foot, also a concern of the woodcut artist. Before you buy any wood examine its surface carefully, remembering that it is not being sold for the purpose of making woodcuts. Any bruises, scratches or sawmarks will probably print quite clearly, although generally a few odd marks can be accommodated in the design or cut away in negative areas. In time you will know what you can manage and what you must discard.

Larger blocks can be made by joining two or three planks together and although almost any area can be covered in this way, a few

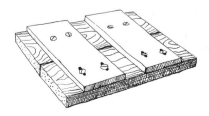

12. Woodblock made from two planks
showing how the back is joined

problems do arise. Wood usually shrinks slightly in time and as a consequence the joints in such multiple blocks are likely to open; this is easily corrected by allowing a slit rather than a hole for the screws in the backing piece, which will make a slight amount of adjustment available when required.

Another problem occurs at the printing stage. If these backing pieces are too small or narrow the block will receive much greater pressure from the press immediately over them, and distinctly darker areas will occur here on the resulting print.

To summarize, these made-up blocks must have well-covering backing pieces and if possible some form of movement to adjust the planks.

This type of fastened together block might seem far too unwieldy, and it is of course quite possible to keep the planks that make up the design separate and print them together on the press or even one at a time. However the inconvenience of having a design in two or three separate pieces that get lost in different parts of the studio will quickly become apparent.

The patterns of knot and grain in pine wood, caused by the differing colours of its hard and soft constituents, will naturally appear when a print is taken from the wood. Many artists like to accentuate these swirling lines by scrubbing away the softer wood from the surface. A scrubbing brush, wire wool or scouring powder will soon remove it. I think a warning is advisable here however; this technique is so immediate and dramatic in effect that the design is quite likely to be completely lost, so some care and deliberation should precede the combining of the natural wood grain pattern with the design.

Like hardwoods, second-hand softwood is readily available, and is often a much more seasoned and stable material than freshly planed planks. Old kitchen tables, often beautifully scrubbed and worn by use, old shelving, drawers, even flooring planks should, when selected, be examined carefully in a strong light for scratches and scars, although again like hardwoods, it is surprising how often these marks—even in considerable number—do not seem to interrupt the design.

Plywood, chipboard, and other composition woods, because they are machine-made, usually have even surfaces and a fairly exact thickness. Chipboard, however, because it is made from small chips pressed together, produces a mottled print that has a somewhat limited use for the artist. Plywood is made of different layers, usually birchwood, glued together with the grain of each layer at right angles

13. Heightened effect of grain from a scrubbed plank

to the previous one to give a thin piece of plywood strength. This means it can be worked quite quickly, the areas to be removed are simply cut around with a knife and the first layer of ply peeled off. Sometimes the glues used to make the plywood are not evenly spread and the wrong areas can begin to come away; these must be reglued carefully before their exact location is lost. It is also advisable with a plywood block to smooth off the edges and round the corners slightly as the ply veneers peel away only too readily if these edges are knocked or scraped as you work.

Blockboard differs slightly from plywood, though it has no particular advantages. The outer veneers of birch have at their centre, slats of softwood, and it is both heavier and cheaper then plywood.

Hardboard is often used where cost is a prime consideration. It has an even and dense consistency that cuts quite well with sharp tools, but the results are often so like linocuts that this softer and altogether easier medium is probably to be preferred when no strong feeling for wood is in the maker's mind.

All these materials are supplied in different thicknesses, grades and qualities.

Tools

Anything that cuts wood can be used as a tool by the woodcut artist. Some suppliers advertise 'woodcut tools' but this is a very small part of the picture. Throughout many years of woodcuts and

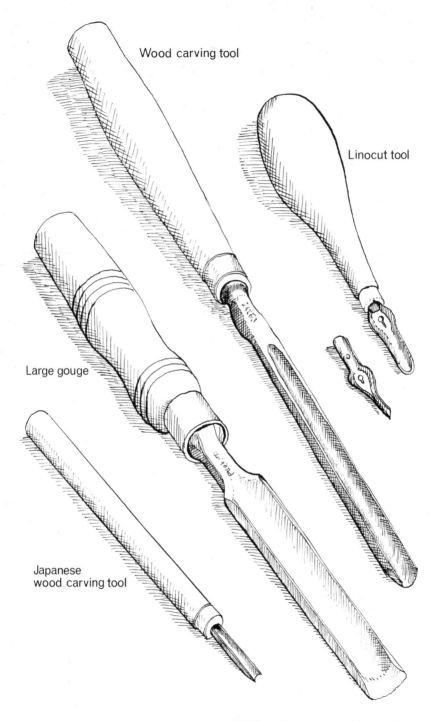

Wood carving tool

Linocut tool

Large gouge

Japanese
wood carving tool

14. Tools that can be used for woodcut

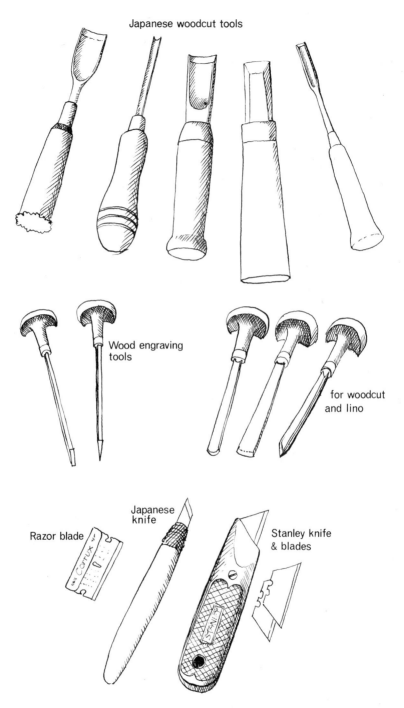

Japanese woodcut tools

Wood engraving tools

for woodcut
and lino

Razor blade

Japanese
knife

Stanley knife
& blades

15. Tools made more specifically for woodcut

21

engraving I have constantly swapped around the tools for each medium and used almost every other tool that has turned up. I myself seldom use more than three: a razor blade, a small lino gouge, and a large round chisel. It is likely that most people will find such a small selection adequate, though you can only find out what suits you by buying one or two tools at a time. I think it is unwise for a beginner to invest in a huge array of tools—he might well end up only using two—and a gleaming array of new gouges can be intimidating enough to spoil the first efforts.

Basically the tools divide into two types; straight knife-edges and round gouges.

In complete contrast to the wood engraver, linocut artist, steel engraver or any other blockmaker, the woodcut artist with his first mark on the block will notice how completely the grain of the wood

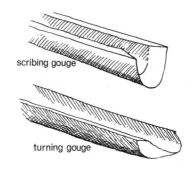

scribing gouge

16. Gouges made for woodworking, also quite suitable for woodcut

turning gouge

dominates his work and subsequently his ideas. He can cut with the grain or across the grain, but unless his tools are well sharpened and he plans each move carefully, the design will be constantly interrupted with splintering edges. The knife-edged tool is the main way of controlling this, and whenever the gouge is likely to cross the grain and start splintering the wood in an uncontrollable manner, the knife-edged tool should be used. Soon these situations will be anticipated as a deeper respect and understanding of the wood is gained.

Although most suppliers and tool shops have many varieties of this tool, artists tend to look even further, employing model-making knives, Stanley knives, razor blades, or even well sharpened pen knives; the classic woodcut tool of this type is called a Japanese knife. Different knives should be tried until those are found that are both comfortable and predictable, since some of the most detailed

and precise work will be required from this edge. I am personally addicted to the single-edged safety razor blade. It is cheap, easy to obtain and, as its corner is blunt it can be broken off with pliers to present a new section of the edge to the block surface. A bit of sticking plaster or insulation tape on the top edge will make the razor blade more comfortable for the index finger.

Round gouges are available in many forms; besides woodcut tools proper, carpenters' tools and woodcarvers chisels are often just as useful. A large selection of different size gouges is not necessary; one or two good big gouges for clearing large areas fairly quickly and one small one is all that is needed. I have found that a large flat chisel used upside down will also clear large areas.

Some artists like to use a V-shaped tool, although I must say I find it an awkward tool to use. A knife will do the same job—admittedly with two cuts—and is much easier to keep sharp. It comes in all sizes and makes a smooth V-shaped groove whose width depends on the tool size or the depth to which the cut is made. On the print the groove shows as a white line.

Sometimes one can find small inexpensive woodcarving sets, usually made in Japan or Singapore. Although the steel is poor and some artists dismiss them, I have occasionally found these tools very useful. Japanese craftsmen explain that they use softer steel so the tool can be sharpened more quickly. But since it must also blunt, it is hard to see where the advantage is, and I have always found it annoying to stop and sharpen tools.

Other tools that may be required are a mallet or hammer, a stone and oil to sharpen the tools with, and some means of holding the

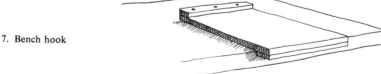

17. Bench hook

block. Clamps can be used to hold the block down onto the work table, but they can so easily scar and mark the printing surface that it seems much safer to use a bench hook or a stop screwed permanently into the worktop.

Hands should always be kept clear of the direction in which the cutting tool is pointing. It is easy to hold the block with one hand and

push the tool with the other. Try to use the stop or bench hook whenever possible; if you have to hold the block, be absolutely sure your hand is behind the cutting edge

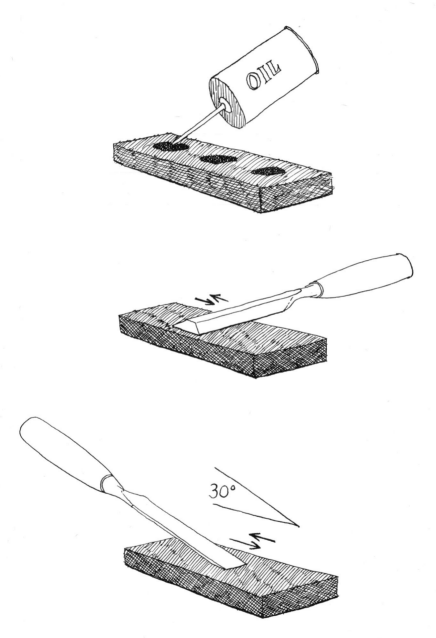

18. How to sharpen a flat chisel

For the beginner who is confused by the many tools and materials available today, the following is a basic starting list:

Block—Sycamore wood or deal plank.
Tools—One sharp knife, one small and one large gouge; a hammer, a sharpening stone with oil, and a wooden stop screwed to the work table.

Sharpening

18 How to sharpen a flat chisel. First oil the stone then make sure the back is flat, if there are any high spots rub the back gently, holding down the chisel with two fingers until it is level. The front edge is worked in the same way but be careful to preserve its thirty degree angle. Finally remove the burr by again rubbing the back on the stone.

19 A scribing gouge is sharpened with a smaller slip stone; first oil inside the gouge and remember to keep the inside angle at thirty degrees, remove the burr on the back at the end.

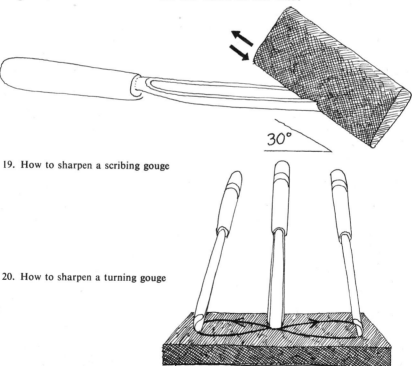

30°

19. How to sharpen a scribing gouge

20. How to sharpen a turning gouge

20 A turning gouge is sharpened with a figure of eight movement on the large stone, try to maintain the thirty degree angle—a difficult job—and remove the burr on the inside with the small slipstone.

C *94859*

Chapter III

Approach to design

For the beginner it is probably more helpful to read this chapter after a few blocks have been cut and some personal views have been reached. My design ideas are more to help a student steer his own individual course because I think it is no help to be strictly directed in the world of image-making and design.

The word design is in such common use today throughout every branch of the visual world that its meaning is often obscure. With most art mediums the conversion of an original idea into graphic form suitable for starting work usually presents problems—woodcut is no exception—these problems are the process of design.

What sort of images, produced in what sort of way will make a woodcut? There is probably no answer to this, certainly no simple answer.

It is a fairly common experience—well aided by the vast amount of art books published today—to be impressed by the extraordinary skill and understanding that great artists like Matisse and Picasso demonstrate while using a completely new technique. How is it that these artists, primarily known and trained for drawing and painting, can work without apparent difficulty in another technique which for most of us would require more than one text book? It must, of course, remain a mystery of their own special genius. However, two particular qualities certainly help; a mind that is so charged with ideas and images that practical difficulties are just butted aside or ignored, and an approach that includes a natural or hard-earned respect for sensing the limitations—and therefore advantages—of a new medium.

I cannot help believing the awful truth that if the few principles of design are not understood naturally, no amount of stating them is likely to help. In spite of this I will present one or two ideas that might be a starting point or a reminder.

The first principle of the woodcut, and this applies to wood engraving and linocut, is that the block is made of two types of surface, bits that print and bits that do not. This might seem rather a crude statement, but recognition of this basic fact often takes a long time to sink in. These mediums are therefore naturally and more essentially two-dimensional than other print techniques. Etching plates can hold different quantities of ink at different thicknesses, the lithographer has various half-tones and depths of tone at his disposal; with the

woodcut block, areas either hold ink or they do not. Consequently, ideas needing atmosphere, depth, or any great subtlety of tone are usually not easy to transmit with woodcut blocks.

One natural approach therefore is to use as many variations on this situation as can be devised. Richness and quality is achieved by changing this negative/positive theme in as many ways as possible. Black, white, black stripes on white, white stripes on black, spots, zig-zags, etc. If the whole block is filled in this manner with different small-scale patterns and textures the close proximity of white and black marks will give an overall grey effect. If much larger areas of white and black are used the opposite results are achieved, which give disruptive, contrasting images.

It is quite a good idea to understand this by cutting a block with no particular image in mind, just areas of black, of pattern, and of

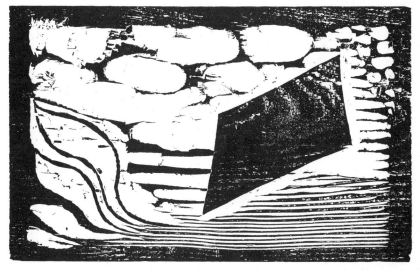

21. Print from a simple exercise block

white (see fig. 21). Black can be made to seem blacker by surrounding it with white, a white spot will look sharpest in a large black space. It often improves a block to make sure there is a large black area somewhere and an obviously white or clear area as well. Cutting a block like this will very quickly show the variations and tones of black, white, and grey that are available to the artist.

In the past woodblocks must have been more difficult to obtain and surface. Certainly designers then managed to condense a great deal of action into very small areas, and it is this 'squashing' process that gives many old woodcuts such a rich and satisfying quality.

27

Nowadays so many designs are conceived on large sheets of paper and carefully transferred to the centre of the block area that many unsuccessful blocks are often necessary before the artist becomes aware of the very important relationship the design must have to the size,

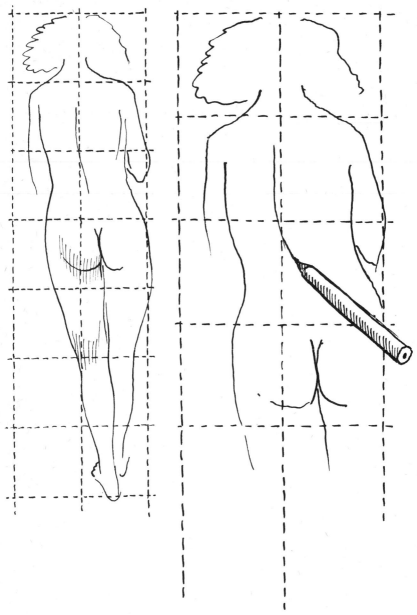

22. The squaring-up method of enlarging drawing

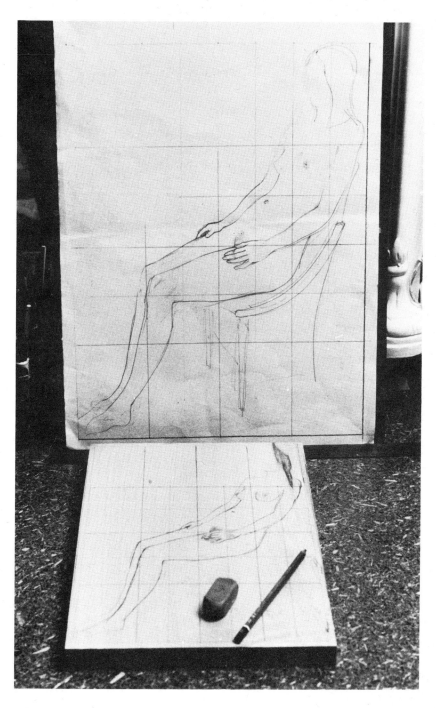

23. The squaring-up method being used to reduce a life drawing for a woodblock

shape and scale of the block. An obvious way to get the size right is to square up the drawing while it is on paper so it can accurately be made larger or smaller to fit the block (see fig. 22). But a far simpler way of forcing an understanding upon the designer is to draw straight onto the block, letting the picture grow on the wood surface. Work with a soft pencil (5B or 6B) and a good rubber, constantly adjusting the drawing to the block, its shape, its edges, and its particular wood grain characteristics. Knots and unusual areas of grain can be accounted for in the picture or the drawing can be changed to suit the wood. Getting images on paper beforehand spoils this whole process.

Any picture can be reproduced on a block made of wood, but a drawing which grows from the wood in this way is more likely to be a true woodcut. The reason for using a very soft pencil is that the surface is not scratched or bruised as of course any indentation will print.

An even more radical exercise is to draw nothing on the block but bravely hack into the surface with a gouge and mallet. Have some image in your mind, a simple pattern, a face, or figure. Use no other tools and ignore pieces of wood that splinter off unintentionally.

A lot of woodcut requires great physical violence and energy—unlike the delicate needle of the etcher—and one or two blocks treated in this way will make woodcut understood more quickly and permanently than many pages of instruction. The German expressionist painters, such as Nolde, Kirchner and Heckel, understood and used woodcut for this very purpose. It is a help with these experimental blocks to print fairly soon after they have been cut, so that the printed effect of each cut is understood.

For the single-colour block an important consideration is its edge. It is usual to leave a border of some sort so that in the printing stage the ink-covered roller will not slip into the lowered areas of the wood-block. Many early woodcuts have complicated and very beautiful borders, and while this sort of complexity is unnecessary, the fact that most relief blocks need careful treatment at the edge when they are printed means that attention should also be given to it at the design stage. However, it is quite possible to have no border, a vignette design can be used, or the outside edge of the block can be cut out so that it takes on the shape of the drawing. My own feeling is that these irregular edges are a bit difficult to deal with because they are not entirely natural to the medium, unless you have started with an old and worn piece of wood or something that is itself irregular.

It is also possible if, at a late stage, you still feel the design is not

fitting properly into the block, to saw a bit off one or even more of the sides of the woodblock.

The whole process is not unlike a sculptor who, faced with a large block of wood or stone, looks and looks until he sees the form that is waiting to emerge. However many drawings he does beforehand it is the block which holds the secret. So with woodcut I believe it is better to work on the wood surface, rather than on endless preparatory drawings.

Colour

The first colour added to a woodcut print many centuries ago was probably simply a watercolour wash; this practice continued for a long time and prints were simply coloured in like a child's colouring book. In the search for ease of reproduction it was, in the end, realised that separate blocks with different engraved areas could be used to print new colours on the same print. The peak of complexity was reached in the eighteenth century with some Japanese woodcuts with as many as fourteen coloured blocks.

For the beginner it is easiest to add one colour that fills the white areas in some places and overlaps the black (or main colour) in others. The same principles apply to the colour block as were used with the first block, the surface can be left solid, patterned, or clear. The colour situation becomes quickly very complicated if a third or fourth block is added, as new colours appear when two or three colours overlap. It is most important if any sort of control is to be exercised to keep to fairly simple colour blocks at first.

This might seem difficult advice to follow when the modern world of prints seems so flooded with colour, but most contemporary artists have spent many years building up a knowledge and feeling for pigments in both transparent and solid form.

It is not difficult to produce an effective, or even dramatic print with many different blocks, especially if you have the benefit of crisp and professional printing facilities. However, a true understanding of colour in prints is not gained so easily; let me repeat that the second block can hardly be too simple, particularly with the first few designs.

It is always instructive to study the way other artists have used the medium of woodcut, and the examples in this book show how diverse prints can be in style and quality, while all yet belonging to the same ancient graphic form.

Chapter IV

Work method with the block

To cut the block little is needed but a sturdy table or bench and fairly good light. A wooden stop should be very firmly screwed into the worktop (if you are right handed this should be towards the left, and vice versa). This is to set the edge of the block against while the most vigorous gouging and chiselling is in progress. If you do not possess a really firm table, do not try to make do with a lightweight one. It is better to screw the stop into the floor and work on your hands and knees, certainly if a mallet is called for. It will soon be appreciated that at this stage a stop that moves or a table that wobbles means an inaccurate cut. A bench hook, mentioned earlier, can be used as well as or instead of a stop.

Not many artists dare to cut straight into an empty surface. I myself usually draw a little into the block first, but for those who have prepared a design separately on paper the question of image reversal must be dealt with.

Most printmakers know, and others very quickly find out, that a printing block holds a picture that is the mirror image of its print. Usually this is of little importance; there are, however, one or two situations where it does matter:

1. When words, letters, or numbers appear.
2. In a picture that is topographical.
3. When a second or subsequent block is being prepared.
4. If the artist decides his picture must face a certain way.

For the print to be the same as the design the image must be reversed on the block. Put the drawing upside down on a light box, and copy it from the other side of the paper. If you do not have a light box tape the drawing onto a bright window instead. Then put the paper, now with mirror images on both sides, so that the original side is against the block. If the design is drawn in pencil you will need no carbon paper. Gently go over the lines once more with the pencil. If you draw too hard the pencil will make a depression in the wood-block which will later print as a white line. This should transfer the original pencil lead onto the block; finally go over the lines again on the wood surface with pencil, ink, or water colour to fix the image.

24. The woodblock and its print showing how the image is reversed

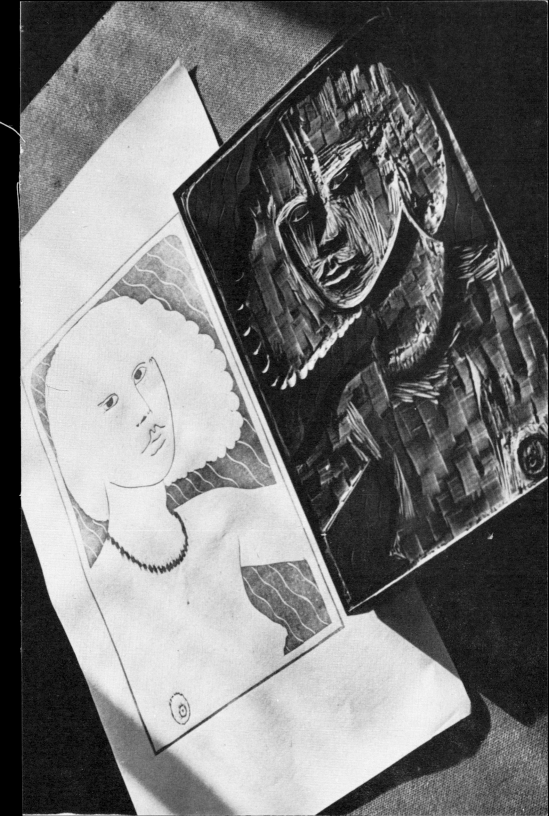

25. A simple light box for tracing

26. The main lines of the design have been cut into the woodblock

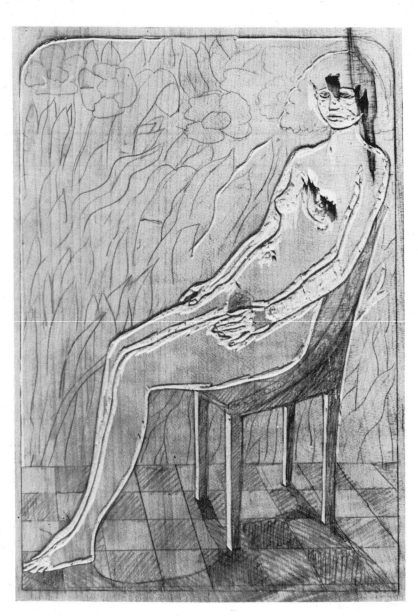

The first cuts are usually narrow lines to establish the design. With a sharp knife or razor blade thick channels or thin hair-like lines can be cut, first an angled cut in one direction, then, with the block turned round a cut from the other side to form a V. This can be accomplished in one movement with a V-tool. Round gouges are used later and the largest areas to be cleared should be left until last, preferably after a proof has been taken.

It takes time to get the feel of chisels and gouges in a side grain block, and the feel will vary with each different type of wood. There are sometimes places on the surface where the grain begins to slant down into the wood and this will catch the gouge unless approached from the opposite direction. Close to a knot the grain becomes denser, looking rather like a whirlpool, and the gouge can get deflected round it. All these small problems will soon be familiar and, as they are anticipated, will become easier to deal with.

Although the print works so strictly in two dimensions, I think the block should always be thought of in three. Never cut straight down, but slope your cuts to give the printing surface strength (see fig. 27).

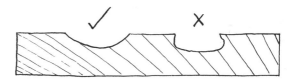

27. Section of a woodblock showing correct and incorrect cutting methods

Always consider the depth to which you are cutting and why. Small flecks and spots will quickly pick up and print in shallow-cut areas, particularly if they are large and wide, and this can often help these otherwise blank spaces. But if a really clear white is needed, these areas must be cut deeper and deeper as they recede from the printing surface. Often it is necessary to take one or two proofs to see where the engraved surface needs further lowering.

If a mistaken cut is made the easiest way to retrieve the situation is to immediately preserve the chip of wood wrongly removed and glue it back onto the block with a good impact glue. All too often the chip flies off onto a large pile of identical chips and cannot be found. If this happens it is possible to prepare a filler (such as plastic wood or plaster and glue), but nothing is really satisfactory. Shrinkage usually occurs, or a slight error in levels, and you can never return to a surface that is quite as good as the original. It is surprising how

often these mistakes can be left on the block to be printed as mistakes.

The Japanese knife, razor blade, or Stanley knife, should always be drawn steadily towards you and held at an angle to the surface. When the line changes direction it is often easier to move the block round, it is also easier and safer to keep the arm and body as one fairly rigid unit with the block against a stop, especially when deep cuts are in progress.

This is perhaps a good place to say something about safety. In the wrong hands most woodworking tools can be lethal instruments, and eager students with sharp new gouges can be a frightening sight. It takes time to get used to new tools and techniques, but there is one simple rule that can save a lot of bloodshed. Never allow a tool to point in the direction of hand, arm or body; *this means keeping yourself completely behind the cutting edges.* With the action of the knife this is not always possible, but if the arm and body are kept rigid as described, injury should be avoided. Teachers who are starting off a class of any sort in blockmaking where sharp tools are involved, should make a point of explaining these rules before any cutting commences. It is often when the most detailed work is in progress, and concentration on a crucial bit is at its full, that a student forgets about protecting his other hand. The importance of the relative position of hand and cutting edge cannot be stressed often enough.

Besides the cuts made with V-tool, gouge, and knife, there are some very useful combination methods of cutting. The knife or razor blade cut can be used as a sharp stop and the gouge stroke brought up to this cut. This is used when a loosely gouged area is next to a sharply defined black. Usually the knife is used to cut both sides of a V, but a different mark is made by cutting one side with a knife and using a gouge for the other. This is more easily done with a small engraving tool or linocut gouge. I have found another very useful cut is to use one of these small gouges with a slight twisting motion: the amount of twist controls the width of the cut and with a bit of practice very subtle and sinuous marks can be made.

As the work progresses a good idea of what the print will be like can be seen by holding the block in front of a mirror. If you have one by the working table you can check any numbers or letters very quickly.

Large areas are usually gouged last, but, it can be difficult manipulating a roller so that it straddles a wide space, so where possible the latter should be avoided.

When the block is nearing completion a proof can be taken; or if

you feel very unsure of yourself a succession of proofs can be printed. Certainly after cutting the first two or three blocks some amount of confidence will be gained and it will become much easier to judge the state of the woodcut. With the first block there is a temptation to take endless proofs to see how the image grows and there is no harm in indulging this; indeed, close touch between cutting and printing at this stage is a help to an understanding of the medium.

Finally, when the design is more or less complete, the last proof should be studied so that the odd flecks can be cleaned up—particularly in the larger gouged areas.

It is worth keeping these working proofs numbered so that later on you can see how the block design developed and grew.

Chapter V

Printing

The press

Presses vary enormously in size and application, but most print-makers come to know the basic two types of press: those that work like an old-fashioned clothes mangle, where the block and paper are forced between large heavy rollers; and those that have a rec-tangular plate that is made to descend with slow but even pressure onto the paper and block. The first type is used by etchers and lithographers, and can sometimes be used for linocuts, some artists even extending their use to other relief blocks, but these presses are really unsuitable machines for woodcuts.

The second type—often called letterpress—is of much more use, and the Albion and Columbian press the best-known names to print-makers. Both were made in different sizes and by different makers, and although not used commercially now, a lot of printing works used them at one time, usually to obtain a quick manual proof of work in progress. It used to be possible, by carefully studying the printing trade papers, to find small firms selling off old equipment which occasionally included a manual press. Now, however, there are few left in ignorant ownership and they usually change hands for sums of money far above a student's pocket. Because many of these old machines are impressive to look at, some printers and publishers are buying them back to sit unused but decorative in their reception rooms. They are a frustrating sight for the printmaker.

It is probably still worth having a look at the trade magazines to see if there are any printing works holding sales or auctions of old machinery. If you cannot obtain your own press you could try asking around for one you could use; some art schools and artists might allow the use of their press to a serious and responsible print-maker.

If you do manage to get one it is well worth having it professionally moved and installed; old presses are made of cast iron which is a surprisingly brittle material and pieces are easily broken by rough handling. You must also remember that most presses are exceedingly heavy (they have to be for even and exact pressure), so you should inspect the floor of your studio very carefully well before the press is due to arrive, as it might need strengthening. It is usual also, unless you are particularly mechanically minded, to have the press profes-sionally assembled and adjusted. Some printing works will, for a fee,

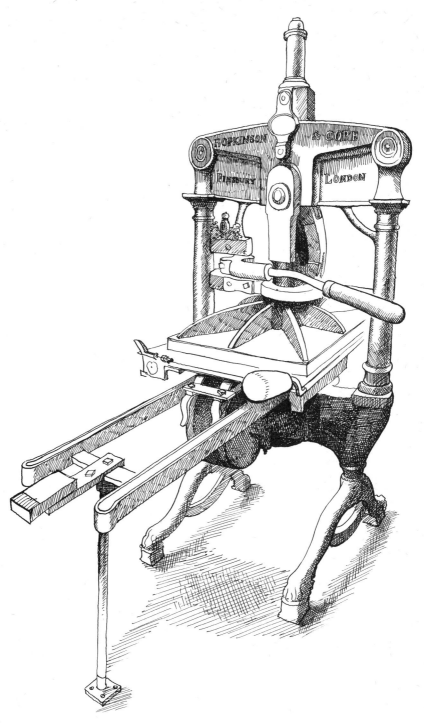

28. The Albion press

send someone along to do this. Do not forget, before he leaves, to ask as much as you can about routine servicing, oiling, and adjusting.

The action of the Albion is very simple. Block and paper are laid on the bed which is then rolled under the pressure plate or platen, then a hand lever is pulled to move the platen slowly down onto the paper and block with a pressure that can be felt at the end of the stroke; the lever is returned, the bed rolled back, and the print peeled off the block.

A few modern presses are made of the multi-purpose type, to print etching plates, litho, lino and wood. They are smaller and lighter than the old-fashioned press and seem altogether a most attractive proposition to the print artist. However, they are expensive and woodcut blocks can be the most difficult to print, requiring at times very sensitive treatment, so you must ensure that your most difficult blocks can be printed before investing in one of these presses.

A much simpler and smaller instrument, by no means to be despised, is the bookbinders press, which just has a large plate that has to be screwed down. It can be used for proofs and small blocks and is sometimes sold second-hand. However, if you have any choice at all, it is always better to get the largest press that is offered. A large press usually has more even pressure and of course will be useful for a much greater range of work.

Paper

The range of paper available today is both enormous and confusing, since a serviceable print can be taken from almost anything from butchers wrapping paper to blotting paper. If you try different surfaces—and it is a good idea to try as many as possible—you will usually find that the best and finest prints come from a paper that is smooth yet soft. Any minute roughness in the surface which many handmade papers have will simply confuse the fine detail—usually the grain—of the block.

For proofs, the clearest prints are made on newsprint, usually quite easy to obtain in large rolls from the print works of a local newspaper. Newsprint is thin and has a very smooth fine surface though its main disadvantage is that, like newspapers, it will not last. It becomes brown and brittle quite quickly and then starts to break up.

The best paper is made especially for printing and can be rather expensive; Japanese papers made from mulberry or bamboo are in this class. Rag paper also is good but very expensive, being made

40

from rag as opposed to woodpulp, it is important to obtain a quality that is 'hot pressed' (H.P.) and therefore smooth surfaced.

It is usual to use unsized or lightly sized paper (Waterleaf, for example), though particularly rich colour can be obtained with sized paper used damp, but if used thus, it must be kept damp throughout the printing process.

Some points to remember are:

Rough edges in some handmade paper could mean problems with registration, so be careful always to cut one corner to a correct right angle.

Paper has a wrong and right side, the maker's mark being readable when the right side faces you, though this side might not suit your purposes.

When using colour it is best to choose paper as white as possible, creamy or off-white paper will only spoil the brilliance of the printed colour. These papers should only be used for special situations.

Like most things, paper is far cheaper bought in bulk. So if you have found a paper that suits you, buy as much at a time as you can afford and can keep.

Basic list of printing papers:

For proofing, use newsprint or cheapest cartridge paper.
For the edition, use quality lithographic cartridge, or the Japanese paper called *Hosho* (Lawrence, Catalogue No. 44).*

Inks

Two types of ink are available for printing, water-based and oil-based. For brilliance of colour, oil is generally to be preferred, but where ease of handling is important—for a class of schoolchildren, or in very limited home conditions—water-colour is better. It also dries more quickly, so overprinting can be more immediate (with some water inks the 'dry' state is itself a bit tacky). The differences in water and oil ink really have to be experienced, for the artist to decide which suits his own needs, but basically water-colour can be more subtle, oil more vital.

Oil printing ink is simply pigment ground up in small particles and combined together with an oil binding medium, usually linseed oil mixed with small amounts of driers and/or reducing mediums.

* See list of supplies.

Linseed oil dries slowly, so 'driers' are sometimes added to speed up this process. Reducing mediums thin out the colour and make it more transparent.

There are many different types of printing ink on the market. Lithographic ink is thick and treacly, that used for etching plates even thicker, while for woodcut, lino, and most relief-blocks, letterpress ink is used.

Manufacturers make small variations in the oil-binding medium to suit different printing conditions; however, there are few situations when the woodcut printer will use other than letterpress ink.

The small particles of colour are often from the same source as artists' oil painting colours. Originally earth colours, Siena, Umber and Ochre came literally from the earth in Sienna and Umbria; they were selected for purity, ground down and the oil mediums added, though these sources are not always used today. Less reliable are the beautiful organic pigments such as madder, Indian yellow and cochineal; they fade in time and more modern mixtures are usually substituted today. The colours made from metals are long lasting, iron produces reds and browns, chromium greens, cadmium yellows and reds. In recent times coal-tar colours have been invented, and are used extensively by commercial ink producers.

Most printing ink firms do not explain the consistency of their products, unlike artists' colour manufacturers, so you must simply go to a firm of good standing and buy their ink on trust.

Though ink is sold in both tins and tubes, I have usually found the latter much easier to handle.

Rollers

The best rollers today are made of plastic, slightly cheaper are gelatine ones with a harder core, usually made of wood. Gelatine rollers have disadvantages: they cannot be used for water colour ink (gelatine is itself water-based, so the roller would soon soften) and they shrink in heat or sunlight; also they do not wear as well as plastic rollers, so the extra cost is worthwhile.

Rollers are usually supplied with surfaces ranging from hard to almost spongy softness, the type of print you want depending on the roller you choose. A soft roller will sink into the depressions of the block slightly and leave small amounts of ink there. A hard roller will ink only the surface.

Different widths of rollers are supplied, a good standard width is four or six inches, but both smaller and larger sizes are obtainable.

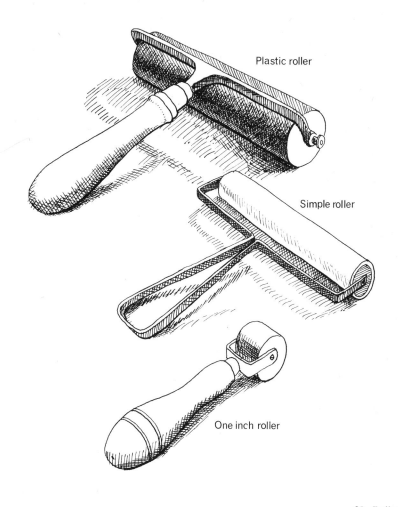

Plastic roller

Simple roller

One inch roller

29. Rollers

Very narrow rollers, an inch or so wide, are used to ink separate areas of the block if two or more colours are to be printed at once.

Good rollers are expensive, but so easily spoiled that of all equipment and tools they need the most care. Never fail to clean them thoroughly after every job, paying particular attention to either edge where the ink tends to collect; always try to put them down on the back of the handle so the roller surface runs free, and store by hanging from their handle ends. Gelatine rollers should in addition be kept away from heat, damp and sunlight.

Cheaper rollers made simply from a rubber sleeve over wood are available and are perfectly all right for small blocks, but their insensitivity will be noticed on large ones.

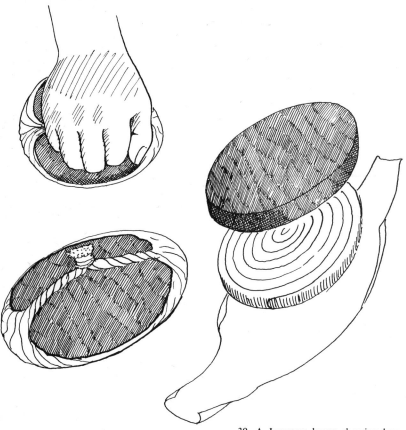

30. A Japanese baren showing how it is put together

Burnishers

When no press is available, prints can be made by rubbing on the back of the printing paper, the implement required for this is a burnisher. Almost anything with a smooth, slightly round back will do, and it helps if it is also comfortable to hold, since burnishing is a long and tiring process. I have for years used an old ink bottle with a slightly domed plastic top, held upside down in the palm of the hand.

In Japan all woodcut printing was done by burnishing—presses were never used—and as a result a highly specialised tool called a baren was developed.

The traditional baren consists of three parts, a centre core, usually a flat spiral of cord twisted from bamboo-husk fibres, then a papier-mâché disk slightly thicker and stronger in the middle and with a slight edge to take the cord spiral, finally a piece of bamboo husk the centre of which forms the rubbing surface with the ends tied round the back to hold everything together and form a grip. This last piece takes the wear and is renewed from time to time.

Many different types of baren exist, some just simple implements of twisted paper, waterproofed and hardened with persimmon juice. Usually artists make their own baren, but some are available from dealers.

The classic tool for burnishing in the West is an ordinary metal or wooden spoon.

Printing

This process put simply is as follows: printing ink is put down on an ink slab, the roller rolls it out until it is evenly spread, then, transferring the roller to the block, a similar action coats the engraved wood surface with a thin even layer of ink. The block is put on the press bed, paper laid over it, registered if necessary, then the press is made to 'press' the paper against the block surface, usually by pulling a lever, and when the block is rolled clear again the final print is pulled off its inky surface. When enough prints have been taken or hung to dry, the block, roller, and inking slab are cleaned carefully.

Before you start any printing you should check the block in the press for height and print pressure. This is best judged by putting a piece of paper (the same thickness as your printing paper) on the block, and trying different combinations of paper, card, and even thicker materials (like blockboard if your woodcut is on plywood) under the block until gentle pressure can be felt on the pulling handle of the press. It is easiest to build up the main packing underneath the block and make final adjustments for each print, with thin paper packing on top of the printing paper. Now, examine the piece of paper that was against the block surface: a slight indentation from the engraved wood should be visible.

It is rarely necessary to use great pressure, though it should be remembered that a large block requires what seems from the pulling handle a far greater pressure to achieve the same indentation as a small one. This is because pull on the press handle equals the product of the pressure and the area involved, as the area increases, so does the required pull.

31. Printing ink laid out on the glass slab ready for rolling up

32. Ink rolled out to a smooth consistency

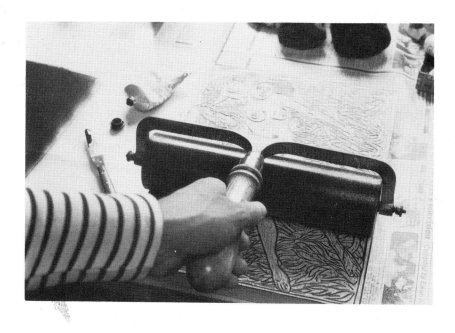

33. Inking the block with smooth even strokes; it is usually not necessary to re-charge the roller from the ink slab

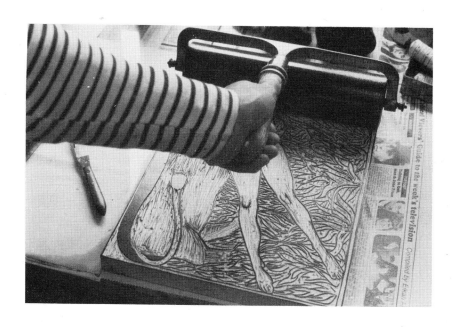

34. Continue to roll until the ink is evenly distributed

47

For rolling out the printing ink a sheet of glass 6mm thick is best; put underneath it a sheet of white paper so that a close approximation to the colour of the ink on the final print will be obtained while rolling up. To mix colours, inks are combined on the ink slab with a pallet knife, then rolled out with the roller. To get a really even distribution of the ink the roller should be lifted frequently, then when the colour and ink density seem correct the block is rolled up with smooth and easy strokes.

The inked block is now placed on the press bed and the paper that is to receive the print carefully put over it. Good paper can easily get marked or smudged, so it is a good idea to hold each sheet with a small piece of paper.

35. Use small clean pieces of paper to hold each sheet

Although it is usual to put only the thin final packing paper on before a print is taken, it is possible to vary the packing by removing some from under the block and putting much more over it. This is done when greater relief is intended in the print. Soft newspaper or even an etching blanket can be put over the block so the paper is forced down into the valleys of the block. This technique is particularly useful if the block is warped or its surface is uneven.

When block and paper have been rolled into the press, printed, rolled back, the first proof is peeled off and examined. If the pressure is too light it will be immediately apparent and if too heavy it will already have been felt while printing. If the pressure is uneven three possibilities arise: the block is not of constant thickness, the press is not correctly adjusted, or the block has not been placed centrally on the press bed.

If the fault lies in the block either the technique described above can be used, or small bits of paper can be inserted into the packing to build up those areas that are printing weakly. Care must be exercised if packing is put above the block: hard edges of pieces of paper can print only too clearly. To avoid this, use pieces that have uneven torn edges, and use plenty of overall packing between them and the block.

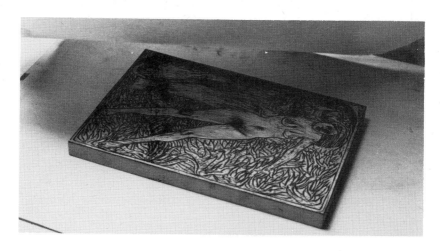

36. Printing paper being placed over inked block

If the pressure from the press is uneven it must, in the end, be properly adjusted, but meanwhile it is a simple matter to turn the block round, taking care to keep the paper exactly located against the inked surface, and print again, thus giving equal pressure, in two turns, to the whole block.

Areas that continue to cause trouble can be burnished carefully until their tone is correct. Once the paper is peeled away from the

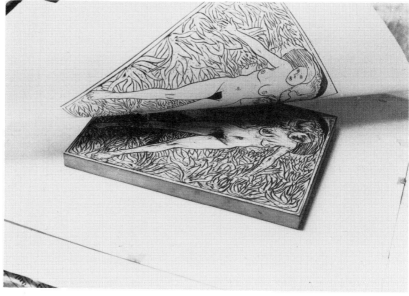

37. Pulling off completed print

49

block it can never be returned without printing a double image. If when you turn up a corner of the proof it is hopelessly under-inked, you can roll on more ink in two stages; first lift off the paper one side, holding the other side firmly against the block surface, re-ink this area, then treat the other side in a similar way. This job is more easily done with something heavy to hold the paper down, or with someone else to help.

It will probably take some time to get results that completely satisfy. There is absolutely no substitute for practical experience, and a few hours printing with a roll of newsprint will enable anyone to discover how much ink, how much rolling, and how much pressure it takes to get a clean clear print.

Burnishing

Burnishing is, in principle, a much simpler process. The block is inked as before, paper placed over it, and then each square millimeter of the paper back is rubbed to transfer the inked image onto its front surface. The paper back can be damaged if it is rubbed too directly, so it is usual to put thin paper or card between burnisher and printing paper. There must be absolutely no movement of the paper while burnishing is in progress and as this can be a very energetic business, skill and patience are required. The edge of the block is also a danger area, a vigorously propelled burnisher can easily tear or damage the paper if it unexpectedly moves over this precipice.

It will soon be understood that this process is entirely different from press printing. Burnishers press the paper against every part of the block, the press only prints from the block's surface plateaux. I have found, on occasions, that this action of the burnisher across

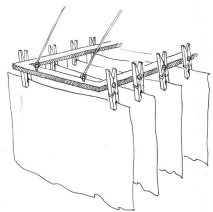

38. A simple drying rack made with clothes pegs

the printed surface, over the edge and down, can produce a less sharp image at the edges than the straight up and down press action. However, burnishing is considered by some a much more accurate way of controlling the tones in a print. Remember that it requires skill and patience, and it also takes much longer to produce a print.

Circumstances may force this method upon the artist, but those who have access to a press can try both methods to decide which suits their personal form of expression.

Finished prints are hung up to dry on special racks. Oil printing ink is usually touch dry in about a day.

Editions

Because of the method of printing and the durability of the material, one woodcut block can, if necessary, produce thousands and thousands of prints. Damage to the block is likely to occur only from bad treatment in storage, woodworm, or splitting and warping due to heat and damp. I do not believe ordinary careful printing causes the slightest wear to woodblocks. However, it is usual to limit the amount of prints taken, the final number arrived at being called the 'edition'. Although the edition can consist of any number from two to 2,000, in practice most people find themselves printing a small edition of 20 or 25, a large edition of 50 to 75, while professionally printed editions are often numbered in thousands. Purchase tax used to be levied only on editions larger than 75, so this number became the most common for printmakers. This situation changed in April 1973 but it is quite possible that this number, to which so many artists and dealers are accustomed, will continue to be used.

It is usual for a few proofs to be existent, signed as such, and not more than ten per cent of the edition in number.

The print should be marked on the bottom left-hand side with the print's own number plus the number in the edition. For instance, 7/25 means that the print is the seventh printed in an edition of 25. To the right is the maker's signature and date. It is quite common to see these marks written in pencil. A print is a mass-produced work, and this numbering is for the dealer or owner to know exactly how mass-produced it has been!

To be absolutely correct, when the whole edition is printed the block should be destroyed or defaced, though I know few artists who do this. It is usually sufficient to make some mark in the block's surface that will show on all succeeding prints. If another edition is then printed, it should be marked in the numbering, as a second

edition. These rules are mostly to satisfy and reassure the collectors' feelings for rarity, since a good print is not made any less good without a number or signature. But since collectors and dealers are the ones that pay for your print it is only fair to document it for them. For your own purposes it is wise to keep a notebook for all editions printed, describing what ink and paper was used, and entering when and where each print was sold.

Chapter VI

Colour and more advanced printing methods

Colour is added to a woodcut, as it is in many other print methods, by making a second block. Onto this second block must be traced the original design so that the colour areas are cut in exactly the right places. This can be done by using tracing and carbon paper on the original drawing, not forgetting image reversal. A more exact way is by offset printing, that is, by taking an over-inked print from the first block, putting this print face down on the second uncut surface and burnishing or printing in the press to transfer the ink onto this new surface. This will give a clear impression of the areas covered by the first printing and the new block can be cut away until the shapes for the next colour remain. Third or fourth colours can be added by making more blocks in the same way.

It is always difficult to print the second and subsequent colours in exactly the right place over the first impression; the problem this

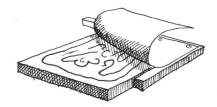

39. Simple registration method for burnishing prints

presents is called 'registration', and it is usually solved in the following manner.

On a large sheet of card, part of the packing under the block, some marks are made so that inked woodblock can be put down in exactly the same place; further marks can then be made for the paper, thus making sure that paper and block are always in the same place relative to each other.

In practice small solid pieces of card or wood are glued to the large sheet of packing card to locate both block and paper without having to align them every time. Be careful to note that these pieces of card or wood for registration must never be higher than the block surface.

There are occasions when one block can be used for two colours by inking different areas with different rollers, but it is better to do this only when the two colours are well separated.

If the separate colours vary much in tone it is usual to print the paler ones first and the darker ones last. The printing ink should be

allowed to dry a bit before another colour is printed on top, although this rule is not followed by all artists.

It is always a difficult matter—as any painter will tell you—to get a number of colours to the right balance; like so many skills time and practice are the only secrets of success. All I can add is that today colour tastes are stronger and brighter than ever and many people tend to forget that some of the most subtle effects are obtained by using carefully chosen neutrals beside bright colours.

One simple colour printing technique used very extensively in schools today is called the reduction or elimination block method. It consists of printing many colours from one block, but cutting more of the surface before each new colour is printed. This method of colour printing first began with linocuts, but the principle applies just as well for woodcut.

It will soon be realised that since the block is altered with each colour change, previous blocks cannot be printed again, so the edition must be printed completely for each colour. The principle of light colours before dark, applies particularly to elimination prints. Though complicated, it is quite possible to make a print from two or more blocks that are each eliminated.

The strong image that most woodcuts provide can be a powerful starting point to further experimentation. If you have a vigorous enough idea, any other sort of block—lino, card or mixed media relief—can be used for succeeding colours, tones and patterns. My own feelings are that powerful ideas and feelings must be very strong indeed for these more complicated methods to succeed. Too often the results are simply brilliant specimens of technical virtuosity, a common sight today in print galleries. It is far better to have ideas and images that drag a technique along behind them rather than a brilliant and skilful method that hopes desperately to be art.

The most ancient colouring method is to print one colour block only with the overall composition, while colouring in specific areas with a brush and watercolour. This might seem a primitive way to achieve colour but the basic rule still applies, that if it achieves the objective aimed at, it is legitimate. If the woodblock is printed with oil ink a sort of registration effect is naturally achieved with water-colour washes because the oil in the ink repels the water-based colour, so there is never any overlap.

One difficulty that occurs is crinkling of the print as the water expands and shrinks the paper. A print that is not completely flat is difficult to mount and frame. This can easily be corrected by stretch-

ing; put the paper face down on a larger sheet of hardboard and dampen its back with a wet rag or sponge, then stick the edges to the hardboard with brown sticky paper. As the print dries it will stretch like a drum and when it is completely dry, you can cut it out with a razor blade and steel rule.

A curious method of colour printing was used by Edvard Munch. With a saw, probably a fretsaw, he cut out parts of his block to roll up with different colours. The block was then re-assembled like a jigsaw puzzle and printed. Obviously there could be no colour overlap (unless two separate jigsaw blocks were used); indeed there would usually be a white line the width of the saw blade between the colours.

It is hard to make this colour method convincing, but like all techniques described here, after one or two trials its advantages and disadvantages become apparent. In a figurative design a wriggly fretsaw edge is inevitably crude, so unless a sort of child's jigsaw effect is desired the colour boundaries should be carefully restricted to large-scale areas.

Block printing of any sort presents alarming colour decisions to anyone who feels unsure in this area. The result can often be a sort of proof mania where you find yourself printing the block in many different colours, then trying many more for your next colour and so on. Anyone who has a knowledge of mathematical permutations and combinations can tell you that the resulting different prints could soon be numbering thousands. So do, by all means, try a few colours, but remember at all times your original idea and bend the printing ink according to your intention. If you have none, it is likely that printing and proofing will consume far more time than the results will ever justify.

Framing and mounting
Many people are unsure about framing woodcuts, and for the print-maker it is usually quite important to have one or two examples of work well mounted.

The most invariable rule for woodcuts and all prints is to keep the mounts two-dimensional. Paintings have depth and more interest in form so their frame mouldings are often deeper and more like a window. Woodcuts are usually quite fiercely flat and their final mounting should reflect this, simple coloured mounts or none at all, narrow frame mouldings. It is wise to choose materials that are simple and quiet, colours that do not snatch the eye away from the print.

One well-tried system of mounting employs only a sheet of glass and one of hardboard, both cut fractionally larger than the outside paper measurement of the print, which is then sandwiched between with clips. These special clips are stocked by most art dealers, and a supply of the mounts in standard paper sizes will be found very useful. A slight but expensive refinement of this system is to use glass with smoothly ground edges and corners.

When a card or paper mount is used this should clear the print area by about one-quarter inch; judge this by the space needed for numbering and signature.

The size and proportion of the mount are best decided by what seems right to your eye, a narrow one is pointless and a huge one will drown the print, but its width is usually the same above and on either

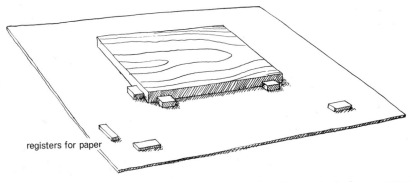

registers for paper

40. Registration method for a press; registers must be lower than the block

side of the picture and slightly wider below. There is a reason for this; as it hangs on a wall a picture seems to the eye to possess a certain weight, so it is sensible to support this weight with a heavier band underneath it.

For showing in folders, where people might want to handle individual prints, simply cut some cheap card to the print's size to use as backing, then cover the front of the print with a larger sheet of thick polythene that is bent round and stuck to the backing card.

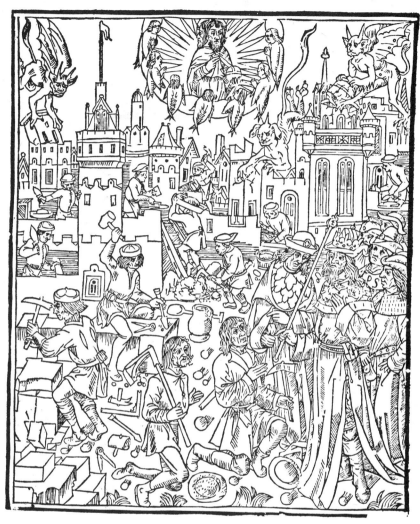

41. Anon, *The Tower of Babel* from *La Mer des Histoires*, Paris, 1543

42. Holbein, *The Expulsion* from *Retratos de las historias del Testamento Viejo*, Lyons, 1543

Apollo en Daphne.

Cupido fier bouen allen minnaers Zinnen
Schoot twee pylen naer de cuenste Zeer euident:
Den eersté was scheerper dan een vliem om minnen
Tonsteken, dander was bot Zo wel t'accident
Vuyjgheefi : want Apollo es vierich insequent
En een ondwerich iagher in Venus wennen
Gheuäghen: Daphne wast noch tgoreel onghewent,
Zo vlietse : mochtse toch met vlien yet verwinnen.

<div align="right">b</div>

43. B. Salomon, *Apollo and Daphne*, Lyons, 1557

44. Anon, *Holy Family*, Spanish, 1548

45 (a). Guasp, *The Conversion of St. Paul*, Spanish 1797

45 (b). Unfinished woodcut, Spanish 18th century

46. Anon, *The Resurrection*, Spanish, 16th century

47. Harunobu, *A Courtesan Watching her Maids make a Snow Dog*, 1797

48. Kuniyoshi (1798–1861), *Askusa Temple in a Snow Storm*

64

49. Kuniyoshi, *Oniwakamaru and the Monster Carp*

50. Kuniyoshi, *The Ship's Captain and the
Monstrous Apparition of the Sea Monk*

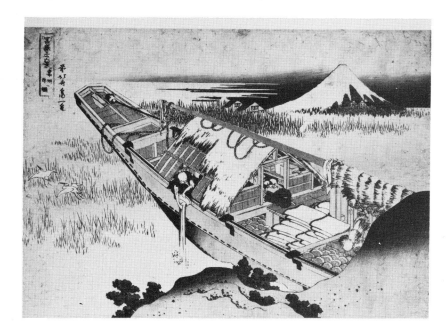

51. Hokusai (1760–1849), *Ushibori in the Province of Hitachi*

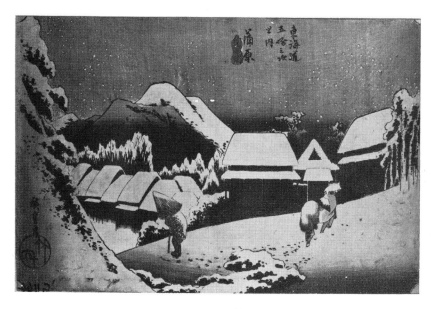

52. Hiroshige (1797–1858), from the set of posting stations on the Tokaido Road

53. Sadahide (19th century), *A Foreigner in Yokahama*

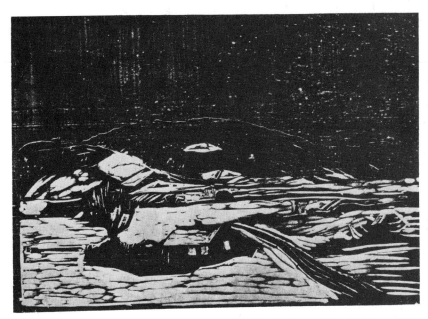

54. Munch, *Large Snow Landscape*, 1898

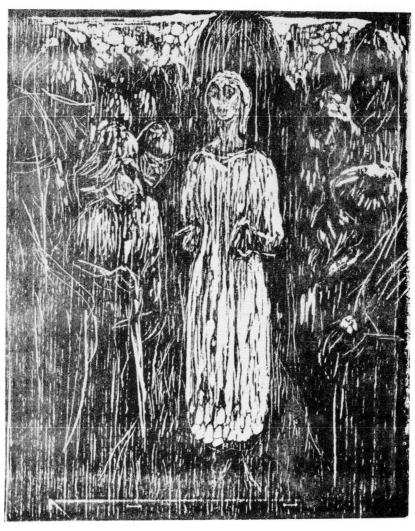

55. Munch, *Trial by Fire*, 1930

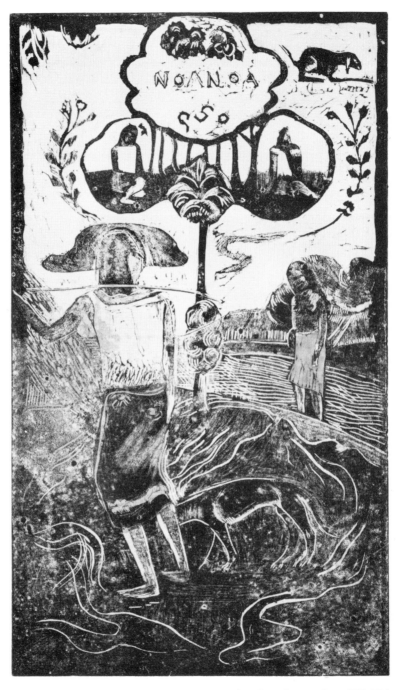

56. Gauguin, *Noa Noa*, 1893-1894

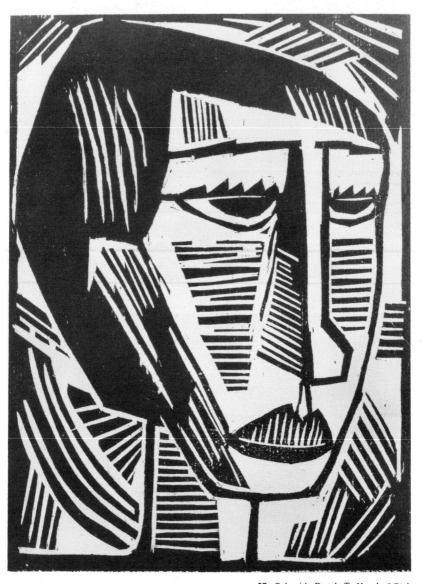

57. Schmidt-Rottluff, *Head of Girl*

58. Schmidt-Rotluff, Title page for the *Neumann Portfolio*, 1919

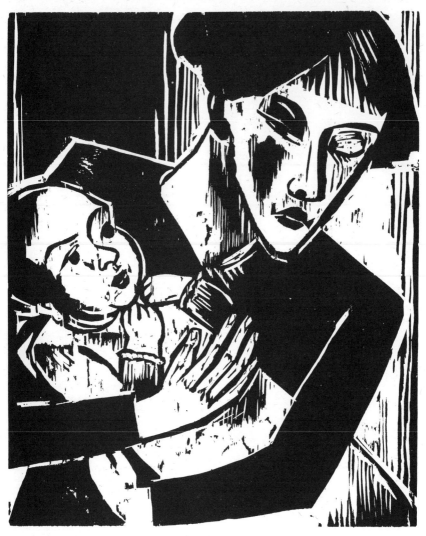

59. Max Pechstein, *Mother and Child*, c. 1922

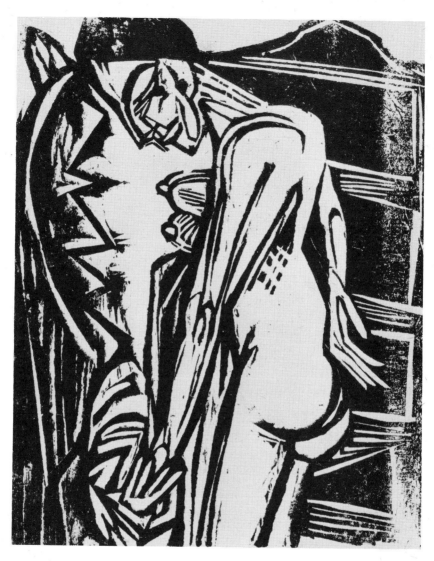

60. Kirchner (1880–1938), *Nude*

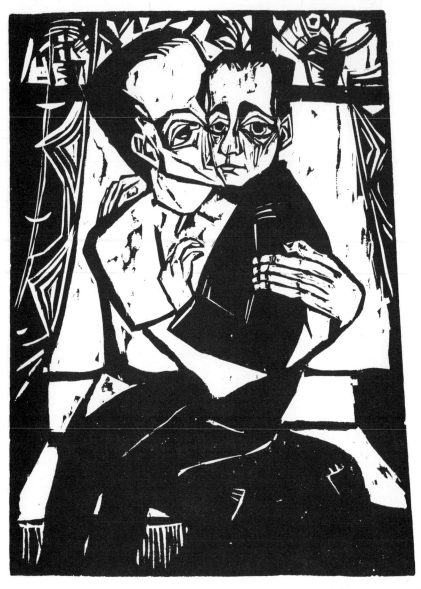

61. Heckel, *Geschwister*, 1913

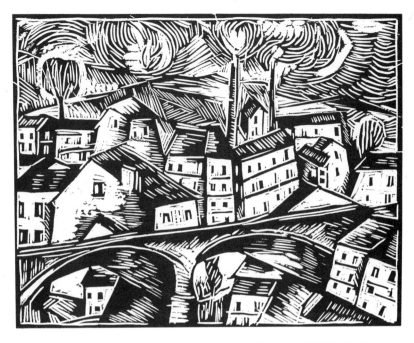

62. Vlaminck (1876-1958), *L'Aqueduc*

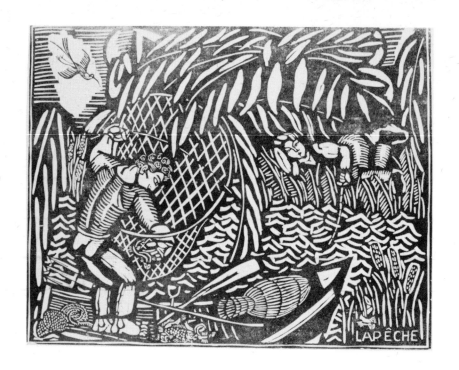

63. R. Dufy (1877–1953), *La Pêche*

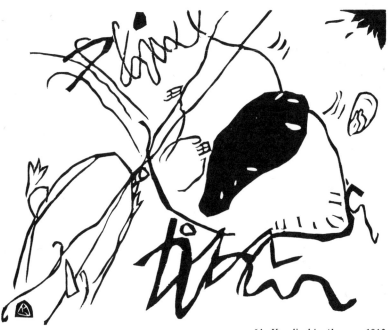

64. Kandinski, *Abstract*, 1913

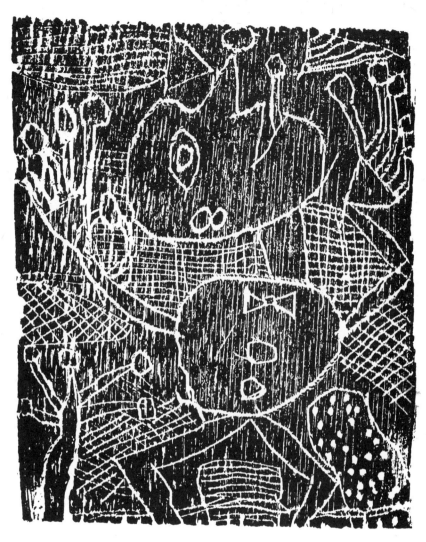

65. Dubuffet, *Tireur de Langue*, cut on a cigar box lid, 1948

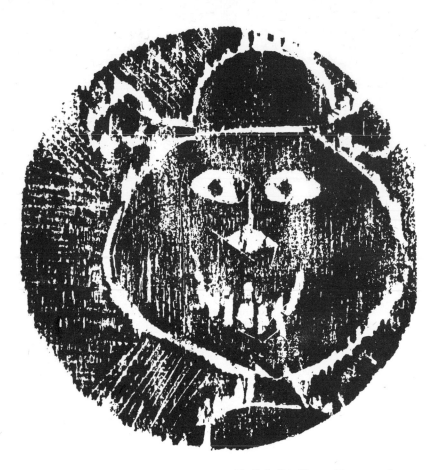

66. Dubuffet, *Tête au Chapeau Melon*, cut on a Camembert box, 1948

67. Dubuffet, *Personnage au Chapeau*, cut
on a piece of veneer, 1948

68. Munakata (1903–00), *Woman's Head*

69. Munakata, *Devil*

70. W. Hutton, *Tiger*, 1963

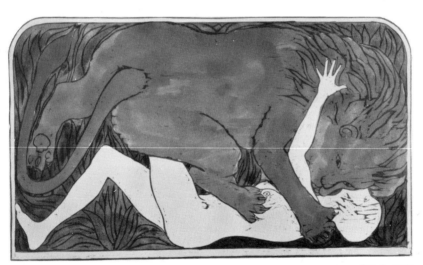

71. W. Hutton, *Lion and Nude*, 1969

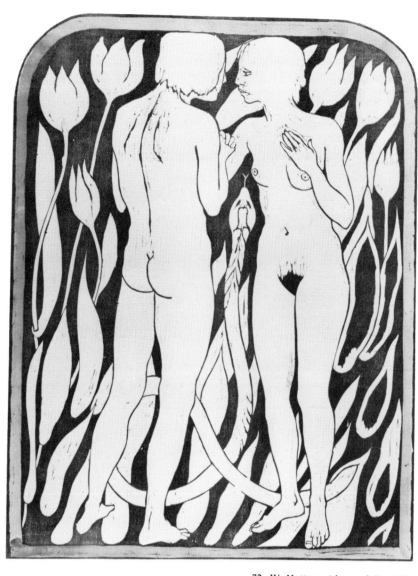

72. W. Hutton, *Adam and Eve*, 1971

U.K. Suppliers

T. N. Lawrence & Son Ltd. 2–4 Bleeding Heart Yard, Greville Street, Hatton Garden, London ECIN 8SL.	Blocks, woodcut tools, sharpening stones, rollers, printing paper, barens.
Dryad, Northgates, Leicester, LE1 4QR.	Tools, simple rollers, paper, simple presses.
Alec Tiranti Ltd., 72 Charlotte Street, London, W.1.	Wood gouges.
George Rowney & Co. Ltd., 12 Percy Street, London, W1A 2PB.	Papers, lino tools and rollers.
Grosvenor Chater & Co. Ltd., 68 Cannon Street, London, EC4N 6AN.	Paper.
Spicer Cowan Ltd., Cavendish Road, Stevenage, Herts.	Paper.
Greens Fine Papers Division, W. & R. Balston Ltd., Springfield Mill, Maidstone, Kent.	Paper.

U.S. Suppliers

Andrews Nelson Whitehead,
7 Laight Street,
New York 10013, N.Y.

Many fine Oriental printing papers.

Apex Printers Rollers Co.,
1541 N. Sixteenth St.,
Saint Louis,
Missouri.

Many types of roller.

The Craftool Company Inc.,
1421 West 240th Street,
Harbor City,
California 90710.

Western and Oriental tools, presses, barens, woodblocks, rollers, paper, inks, etc.

Acknowledgements

I would like to record my thanks to all those who have helped me while I was in the process of writing and preparing this book. For supplying me with photographs, I am especially grateful to the following:

Secretariat de Jean Dubuffet, Paris.

P. & D. Colnaghi & Co., London.

Japan Information Centre, London.

Oslo Kommunes Kunstsamlinger, Norway.

The photographs for plates, 8, 60, 61, are by courtesy of Marlborough Fine Art (London) Ltd.

Plates 3, 5, 41–43, 47–53, 57, 58, 62, 64, are from the Victoria and Albert Museum, Crown Copyright.

I am particularly indebted to my wife, whose orderliness and judgement were constantly needed and supplied, and to Julia Ball, without whose help, especially in printing matters, this book might never have appeared.

Bibliography

The Complete Woodcuts of Albrecht Dürer edited by Dr Willi Kurth, Crown Publishers, New York, 1946.

The Life and Art of Albrecht Dürer Erwin Panofsky, Princeton University Press, 1955.

Contemporary Printmaking in Japan Ronald G. Robertson, Zokeisha Publications Ltd., Tokyo & Crown Publishers Inc., New York, 1965.

Great Prints & Printmakers Herman J. Wechsler, Thames & Hudson, London, 1967.

Linocuts & Woodcuts Michael Rothenstein, Studio Vista, London, 1962, and Watson-Guptill, New York.

Relief Printmaking Michael Rothenstein, Studio Vista, London, 1970, and Watson-Guptill, New York.

Edvard Munch J. P. Hodin, Thames & Hudson, London, 1972, and Praeger, New York.

Edvard Munch Graphik Ole Sarvig, 1948 and 1965.

Starting with Relief Printing Cyril Kent, Studio Vista, London, 1970, and Watson-Guptill, New York.

Creative Printmaking Peter Green, Batsford, 1964, and Watson-Guptill, New York.

Introducing Relief Printing John O'Connor, Batsford, 1973.